OIL PAINTING TECHNIQUES

By William F. Powell

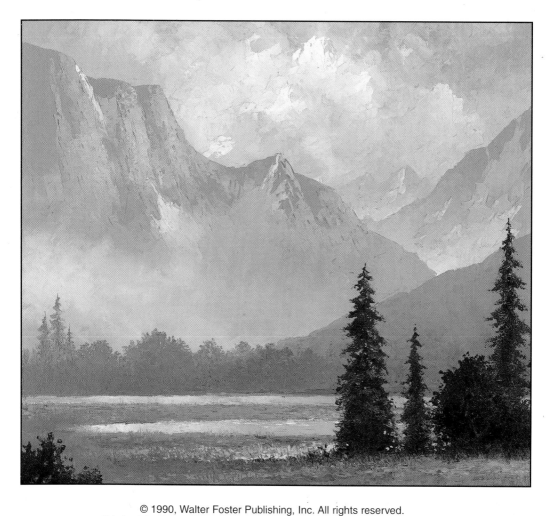

Contents

Introduction

My knife techniques were developed through trial and error. Many years ago, I decided to try something new. Although I had only two styles of knives, I used them to create a total knife painting. Not only did I find knife painting enjoyable, but also the results were quite surprising. For example, the smooth knife blends allow the colors to appear crisp, fresh, and clear—unlike the surface textures from brush bristles that catch light rays, creating a dull look on the surface of the work.

When I introduce knife painting techniques to my classes, the students often complain that knife paintings are too rough and unrecognizable. Most would rather continue with the brush techniques they had been taught to use.

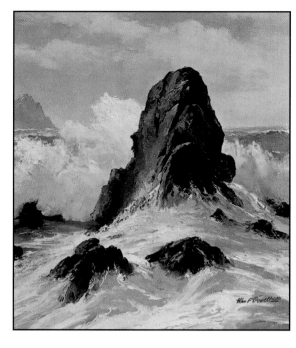

I explain that a good artist should be versatile and that the knife can be a very important tool. A skilled knife artisan can create extremely detailed work. Also, smoother blends of color can result with a knife compared with those made with a brush. For those who have never tried the knife, this fact may be hard to believe. After seeing the beautiful things that happen to color while using a knife, however, artists and students are quickly convinced.

As previously stated, many artists are reluctant to try knife painting—but, as they progress with the exercises and create a major painting, they become intrigued with the beautiful colors and textures that can be obtained with a knife. In all my years of teaching, I have never met a student who did not learn to appreciate the value of knife painting.

Some Advantages of Knife Painting

The art of knife painting is enjoyable and exciting. With a knife as a painting tool, one can attain certain effects that cannot be accomplished with a brush. Knife techniques can also be combined with brush work to enhance an area within a painting.

Rich, Smooth Colors: Smooth knife work leaves no brush bristle textures on the surface to create shadows on the face of the work. This permits the colors to appear fresh and clean; colors appear as brilliant as originally mixed.

Various Textures: The knife is great for applying colors over large areas, often faster than with a brush. This spontaneity helps the artist avoid overworking the painting. Moreover, the knife can be used to create varying degrees of texture. It's like icing a cake or lathing a wall— the surface can be either smooth or textured. Planned textures are valuable and add to the composition. For example, creating a texture that suggests wavelets in a seascape adds to the realism of the painting.

Blending

A technique known as "wet-on-wet" involves applying layers of paint over one another without waiting for the colors to dry in between. Both thick and thin colors can be laid directly over an undercolor without destroying it. Colors can be blended into one another smoothly or loosely, and gentle tool handling creates extremely delicate color changes.

Subject Detail

With care, the knife can be used to create extremely fine detail. The smooth surface and edge, as well as the stiffness of the tool, provide delicate blends. The tip can be used to work tiny areas such as delicate, distant pine trees.

Less Odor and No Brushes to Clean

Because mediums, turps, and thinners are unnecessary with this technique, the air in your work area will be less odorous. Moreover, cleanup is no problem; simply wipe your knives clean. A simple wipe of the knife before changing colors is much easier than trying to clean a brush. Caution: Knife edges become very sharp with use, so wipe them carefully.

As you progress through this book, more exciting things will be discovered about knife painting. It is best that you do not skip around because the book has been carefully organized into a progressive explanation and study. Follow it through step by step, and practice the many painting techniques and exercises. Try out different shaped knives to get the feel of them before attacking a major painting. It is not difficult, even if you have never painted with a knife. By following this planned program, you will be knife painting in no time at all!

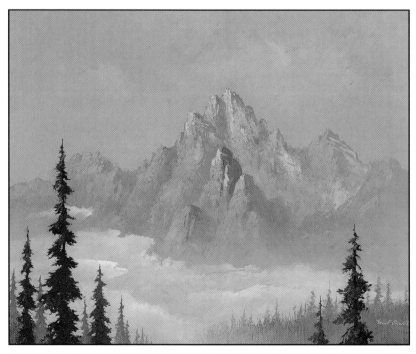

In this painting, titled *Above the Timberline,* loose, rough paint applications are combined with smooth blends. Using blends for the mist areas adds to the illusion of aerial perspective, thus creating atmosphere within the painting. This painting was created solely with knives.

Tools and Materials

Palette Knives

Palette knives are used for mixing paint. They are available in several styles and materials, often of a wood/metal combination or plastic. The two most common styles are shown at right. The traditional long, straight, flat-bladed knives are clumsier than those with elevated handles. The elevated handle (extreme left) allows for control of the mixture while keeping hands out of the paint.

Palette knives should be used with a smooth, gentle, kneading stroke rather than a heavy stirring motion. If paint colors are overmixed, they tend to lose their freshness.

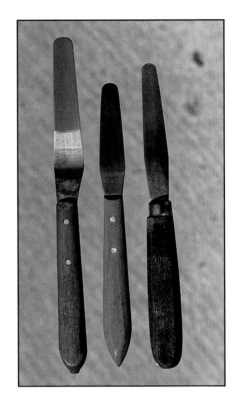

Painting Knives

Painting knives can be used to create extremely fine works of art. They come in many shapes, styles, and sizes. Some artists even grind and alter the blades to create a "custom-made" knife. A good painting knife must be thin, flexible, and sensitive to the touch. Made of hand-tempered steel, these knives are usually one solid piece; some knives, however, are soldered or welded.

The most versatile style of painting knife, in my opinion, is tear-shaped with a small, rounded tip (shown at right). This knife has no sharp angles to accidentally dig into the canvas. My favorite knives are shown on the extreme right and left. I occasionally use the knife in the middle for larger detail.

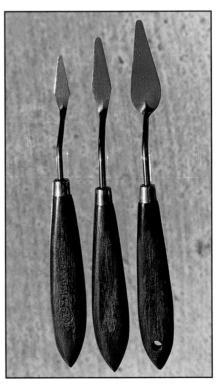

Drawing Equipment

A number of media can be used to draw on the painting surface. Carbon pencils, charcoal, and even paint thinned with turpentine or thinner can be used. My favorite is paint thinned with odorless art thinner. Various brands of odorless thinner are available at art supply stores.

Painting Surfaces

The ideal surface for knife painting is one with enough "tooth" (texture) to accept the paint. Canvas is perfect for small- to medium-sized paintings. Very large-sized paintings or techniques using extremely thick paint should be placed on a firm support such as fiber board. Caution: Over time, the weight of large amounts of paint can cause a canvas to sag and the paint to crack.

Rags and Paper Towels

Rags can be used to quickly wipe a knife clean. Paper towels do an adequate job but are stiffer and sometimes leave a residue of color on the knife. Care should be taken when wiping painting knives because the edges become extremely sharp over time. When painting, the action is akin to strapping them like a razor.

Mediums and Thinners

The viscosity of the paint should be rather firm for knife painting. A fluid paint is more difficult to manage and will not hold its shape. To bring an extra stiff color into consistency of other colors, a small amount of medium (oil) can be used sparingly. Thinners are used occasionally to clean stubborn residue, such as Prussian blue, from the blade of a painting or mixing knife.

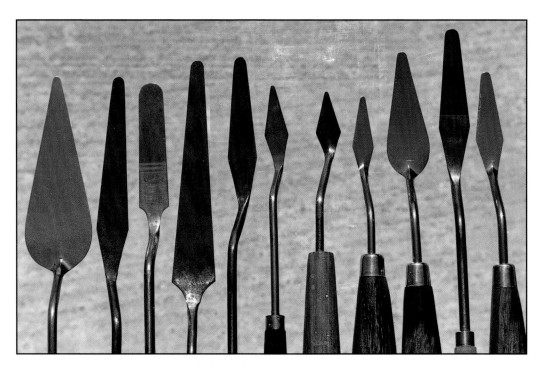

Knife Shapes and Sizes

Many different knife shapes and sizes are available (pictured above). Each knife has its own characteristics. Very long knives are great for blending large areas of color, while short knives are good for textures, details, and smaller blends. Knife tips vary as well. Finer, smaller, rounded tips can create more detail than the larger, rounded tips. A sharp-pointed tip, however, carries very little paint. Experiment with different styles and sizes.

Knife Working Areas

The shape of the side of each knife dictates the required working area for spreading and blending colors. At left are two illustrations showing the working areas for those knife shapes. Throughout this book, close-up illustrations are shown of various knife-working surfaces and edges for applying paint, blending color, and creating detail.

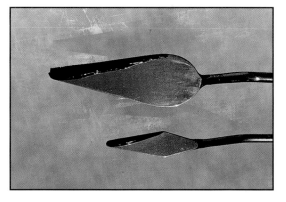

Selecting Knives

Knife selection is important. All knives will spread paint onto the canvas in some manner. However, each knife has a slightly different shape and, therefore, performs differently. One of the most important things to look for is "spring" in the blade. A painting knife should not be stiff; it should be very flexible, especially at the tip. When pushing the tip upward with your

finger, it should curve easily. Curving should take place toward the tip and within at least one-fourth of the blade. Knives become more flexible with use.

Looking across the blade, one can see a variation of thickness from the handle to the tip. The thickest part of the blade is at the hilt, or handle, and the thinnest is at the tip. This thin blade allows for delicate application and manipulation of paint. A sharply pointed knife tip will not carry as much paint as one that is slightly rounded. The rounded tip can create delicate detail even though the tip appears to be slightly blunt.

Pressing too hard with a stiff knife can damage the canvas. With a gentle push, a flexible knife will curve and apply paint in either a thick or thin manner. Textures to suggest plastered walls, tree trunks, ocean waves, mountain faces, and so on, can be created. Select a knife with good flexibility and spring memory.

Remember: As a knife becomes more flexible, the edges become sharper with use. Be careful, they can cut! To dull the edge, buff with a very fine file—but do not overdull. The edge is an important part of the painting tool. Polish any rough areas with fine steel wool.

Holding the Knife

I have several tips regarding ways to and not to hold a painting knife: If the forefinger is placed on the top, as shown at right, it makes the tool seem very stiff and less mobile. Using this position, movement is limited to the wrist.

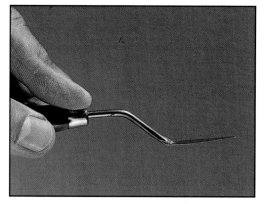

It doesn't matter if you are left handed or right handed, the knife works the same. When a left hander pushes, a right hander pulls, and vice versa. It's that simple. Often, students say my knife works differently because I am left handed. They soon find out that this is not true. Also, I occasionally change hands when knife painting. Experiment using your other hand. Notice how easy it is to change hands with a knife.

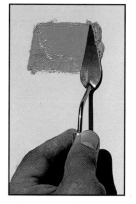
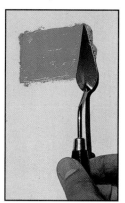

To gain control of the knife, hold it lightly in the fingers, using the wrist and fingers to move it. Holding the knife handle lightly in the fingers enables control and movement in all directions. The knife can also be rolled between the fingers while applying paint. This aids paint manipulation and assists in creating all sorts of textures. Because you can easily sense slight knife movements and pressure changes with this method, there is less chance of pushing too hard.

When drawing with the tip, hold the knife gently in the fingers as shown. Change pressure by squeezing the handle firmly or lightly. Press as needed while moving the knife to allow the paint to be pulled from the tip. Change the angle to apply more or less paint. Also, twirling the knife between the fingers can alter the flow of color.

Painting Techniques and Tips

Knives perform exactly as the user makes them; paint performs exactly as the knife makes it. A painting knife can be used to create extremely smooth or rough finishes to a painting's surface; it can also create smooth or rough blends of color. With practice, a knife can become a magnificent tool for producing beautiful works of art.

Paint Characteristics

Knife painting techniques can be used with media other than oil. Any thick paint that can be applied and manipulated on the painting surface with a stiff tool qualifies for knife painting. Thin, syrup-like paints will not work well at all. To a great degree, the beauty of knife painting is the impasto appearance of both paint and color. The illustration at right shows how thin, syrupy paints—such as tempera and thinned acrylics and oils—lack body.

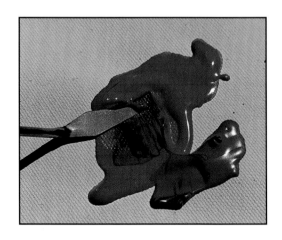

Acrylic paint can be used successfully with the knife. However, there are great differences in the working qualities between acrylic and oil paints. Often, **acrylic gel** is added to the paint to make it stiffer in consistency. This gel is a whitish color at first but clears as it dries. Acrylics dry quite fast and do not allow the painter to dawdle. Applying acrylic paint to canvas and then blending it with a knife wetted with water helps the consistency. Some beautiful color blends are possible. Still, acrylics are more difficult to blend than oil because of their fast-drying quality. Viscosity and drying time make acrylic a perfect paint for more quick impressionistic work with a lot of overlapping and weaving of sharp, fresh colors. Test some acrylic paint and notice how different it is from oil.

In my opinion, oil is the best-suited medium for knife painting. It has a rich, lustrous color and an ease of manageability. Notice in this illustration how the thick body of oil lends itself to knife painting. Most oil colors also dry with more luster and gloss than many other types of paint.

When used thickly, some oil colors will dry with a dull sheen while others appear glossy. Some rich, dark colors can become dull with a slight grayish cast, thus creating an uneven look to the picture. To restore the luster and refresh the color, apply a very light coating of **Damar retouch varnish**. This shows the true color for matching purposes. Damar retouch varnish comes in both liquid and spray can forms. Make certain the painting is dry to the touch before applying this varnish. Also, be sure to use Damar *retouch* for this purpose—not Damar final varnish. Plain Damar final varnish should be used only as a protective coating on a finished work and then applied only when the painting is completely dry. (Also see Walter Foster's *Oil Painting Materials and Their Uses*, #AL17.)

The following section addresses basic oil painting techniques using knives. Practice each of the examples and exercises. Experience is the best way to learn the intricacies of knife work.

Let's begin with some basic knife strokes.

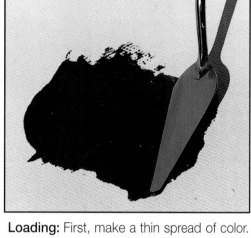

Mixing: Painting knives are used with gentle kneading strokes to mix colors. Loosely mixed colors appear more lively than over-mixed ones. Caution: Do not scrape a paper palette too hard or little furry "roll ups" will mix with the paint and destroy the mix.

Loading: First, make a thin spread of color. This makes it easier for the knife to pick up an even load of pigment. Then raise the leading knife edge and drag the trailing edge to load paint on one edge. Paint is then applied from the trailing edge of the knife.

Leading Edge: Raise the leading edge of the knife slightly. This allows the paint to roll off the underside smoothly. If it is raised too much, the trailing edge will dig in, removing color already applied. Hold the knife with your fingers, and use a gentle touch.

Coverage Strokes: This requires a good load of paint, which can be drawn out to cover a large area. Strokes can be made in any direction, but, for maximum coverage, use the side of the knife and make the stroke smooth and continuous.

Thick Paint: Several layers of thick color can be applied over other layers of wet paint without disturbing them. A gentle touch is necessary. Here is an example of thick paint layered over two other wet layers. Use this method where color buildup and texture are desired without blends. Note: The viscosity of paint on the knife should be a bit thinner than the wet paint on the canvas. If the paint on the knife is too stiff, it removes or digs into the previous layer.

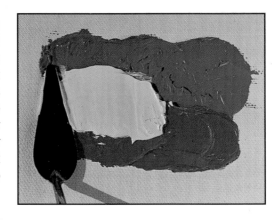

Thin Paint: Paint can be applied thinly to create a very smooth surface, sometimes allowing the grain of the canvas to show. Fine blending of colors is possible. However, blending can become difficult if the colors are too thin because there is not enough body in the paint to apply or manipulate. Feel the consistency of your paint, and always apply enough to accomplish the desired blends.

Changing Directions: By moving the wrist and elbow, strokes can be made in different directions. This creates interest in an area that may not contain any dramatic subject anatomy. By overlapping strokes, many patterns, textures, and blends are created. Notice how these overlapping, blended colors create a rich and interesting color mood.

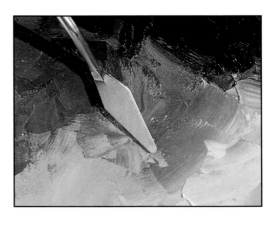

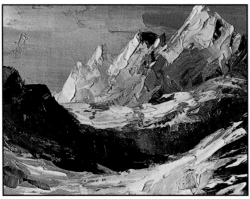

Combined Strokes: By changing directions (as shown above) and combining long and short strokes with those made using different length knives, interesting textures and blends can be created. The possibilities are endless and, when using a good fresh color scheme, the results can be dramatic. This illustration shows combined strokes using fairly thick paint.

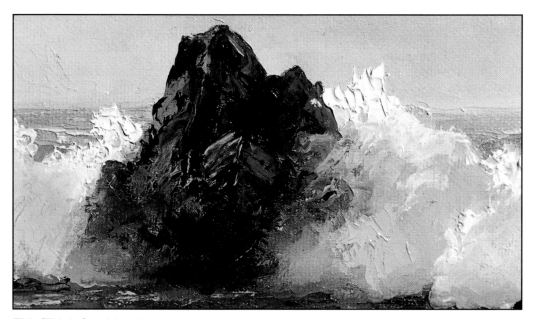

Thin/Thick Combined: Here, thin color is applied alternately with thick color to create a patterned feeling to the subject matter. This type of stroke and the interweaving color keep the work fresh and add to the texture of the subjects. Strokes should follow the shape of an object, as shown here on the rock and in the foam.

Dot Strokes: Using the smaller knife, or the tip of the larger one, paint can be applied in small dot-like masses. This technique can be used to add color, life, and texture to an uninteresting area without making major changes. Because uniformity will attract the eye, it is best to avoid creating a monotonous or uniform pattern when using these dots.

Side Strokes: This illustration shows many of the strokes that can be made by drawing the knife sideways. Some strokes are straight, others are curved. Paint can even be smeared, as if mixing it. Practice these strokes on a painting pad or extra scraps of canvas. This is a great way to become accustomed to the feel of the knife. Later, we will practice "pulling" strokes and double loading the knife with two colors.

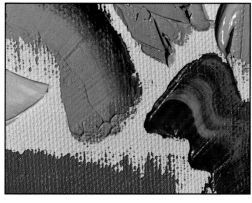

Blending Colors

There are many approaches to blending colors with a knife. It is time to practice some of these techniques. For clarity of presentation, some techniques are shown in one illustration and others in several steps. At right is a simple technique—pull sideways through two roughly applied colors. Raise the leading edge of the knife slightly.

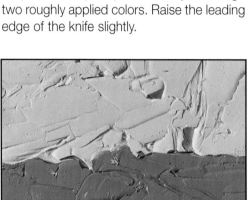

Sawtooth blend: This method produces a controlled blend of two or more colors. To begin, apply two colors to the surface as shown at left. Make them semithick so there will be enough paint to manipulate. Remember, each time the color is stroked and the knife wiped in blending, paint is removed from the canvas. Wipe the knife clean between each blended stroke.

Next, lay the knife over the two colors and raise the leading edge ever so slightly to make the trailing edge blend the colors. Proceed with caution; if the edge is raised too much, it will scrape color away. Next, move the knife up and down while pulling to the right or left. It works either way. Keep the knife in contact with the paint. If the knife is lifted off, it will create a "picket fence" effect, disallowing a smooth final blend.

This technique is called the "sawtooth" because the middle step creates a pattern resembling the teeth of a saw. Sometimes you might wish to use the texture created in the last step without blending. To blend, wipe the knife clean and place it over the sawtooth as shown. Raise the leading edge slightly and draw the knife to the right or left. Either way works. Notice the smooth blend achieved using this sawtooth technique.

To attain these clouds, roughly place colors in a general shape, and then blend by dragging the knife over them. Do not press hard when blending. If the area is not overworked, the basic shape will remain; however, the edges will be softened.

The illusion of mist and haze is accomplished by blending a lighter color into the horizon sky. This is usually done before placing the final mountain shape in front of it. Here, the smaller knife is used to make blending strokes in different directions. By changing directions while blending, color and texture are moved in such a way to produce a feeling of atmosphere.

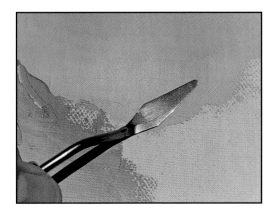

Here, the water surface was blended by roughly applying the colors and then lightly dragging a small knife across them. With water, a surface effect stroke is drawn horizontally and a reflective stroke vertically.

Pulling and Blending Strokes

Many of the strokes to this point have been made by drawing the knife to the side. Now we need to practice pulling strokes. Pulling strokes are very important in knife painting, because they can produce various effects. Practice these sample exercises.

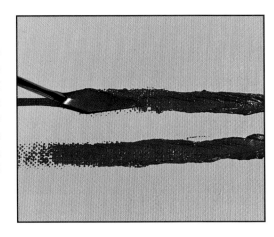

Pulling: Load the knife fully with paint. Place it flatly on the canvas surface and pull. Use the handle as a guide for making a straight pull. The paint is dragged from the knife in a completely different manner than with the side stroke. This can be used to change the monotony of a stroke within an area of a painting or for general color application. All strokes can be made with any size knife.

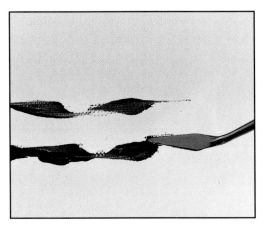

Rolling: Load the knife again and place one edge on the canvas. Start the stroke by pulling the knife and rolling it slightly between the fingers. This will create a broken pattern that can be used to enliven an otherwise flat area. It can also be used to build color in an interesting way. Use it in combination with other strokes.

Double Loading: This is another important technique. This means loading the knife with two colors at once. A double load creates an automatic blending of the two colors as they are painted applied to the canvas. Here are two knives loaded differently: One with colors side by side and the other with colors loaded top and bottom. Blends can be made by stroking in a straight, curved, or wavy manner.

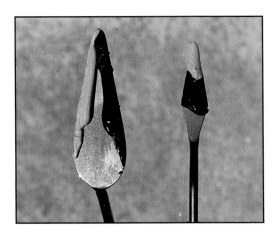

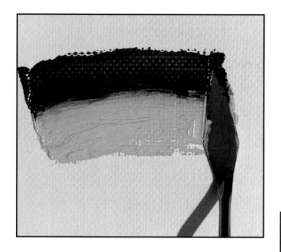

The paint is loaded top and bottom and blended as it is applied using a slightly curving stroke. This application could be used when painting rounded objects, such as vases, rocks, and tree trunks. Try different colors and combinations.

In this example, the paint is loaded side by side, and the double-loaded knife creates a loose impression of textured leaves or foliage. By changing direction and slightly tapping the knife, a rough blend is created that suggests a textured surface on the leaf forms.

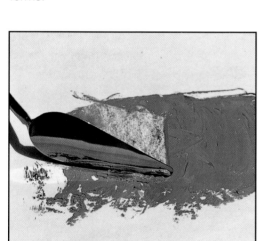

Loading for Lines: To paint thin lines, paint must be loaded onto the very edge of the knife. To do this, make a thin smear of color on your palette and then drag the trailing edge of a clean knife through it until the right amount has built up on the edge.

Drawing Lines: Now place the loaded edge onto the canvas and make lines by either drawing the knife upward or downward or by stamping or tapping it against the surface. Hold the knife at more of an angle to make the lines thinner; less for thicker lines. It takes a little practice, but it is worth the effort. Practice this stroke in the following exercises for weeds and grass.

Weeds and Grass: Paint a thin mix of white and blue on the canvas to represent a simple sky. Use white and burnt umber to suggest ground. Then, load the knife with a thin roll of green paint on one edge. Place that edge on the canvas and draw the knife downward allowing the paint to slide off in a thin line. Turning the knife creates curves; rolling it slightly controls the amount of paint deposited.

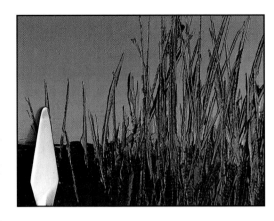

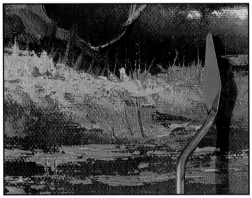

In the last exercise, weeds and grass were accomplished by applying paint. Here, an illusion is created by manipulating already applied paint. Use the side edge of a clean knife and with an upward movement push thin lines of paint over the background color. Lift the knife off while moving to make thin pointed ends. This creates the look of weeds and grass.

Weeds, grass, and foliage can be painted using the tip of the knife. A fairly sharp-pointed knife is good here for making very thin lines of grass and light detail. Removing wet paint to make the effect is subtractive painting. Combine both techniques—positive and subtractive—to obtain variation in depth and realism.

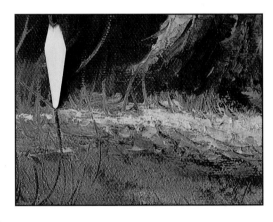

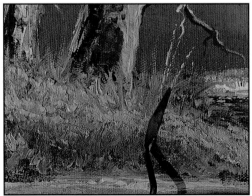

Make grass and weeds overlap forms, such as rocks, logs, and tree trunks, so these objects do not appear to be floating. Overlapping helps "plant" them so they appear solid. Notice how the tree trunks appear to be a natural part of the foreground due to the overlapping grass.

Tree Trunks and Bark: The knife is perfect for creating texture for bark and tree trunks. Strokes should be applied and then left alone. First, paint a basic trunk silhouette using burnt umber. Then load a knife with yellow ochre, and make several side strokes from left to right. Do not blend, otherwise the spontaneity and freshness of this rough look will be lost.

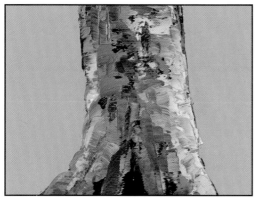

Here, the knife automatically leaves holes in the paint to create the illusion of bark. Stroke with a quick, slightly upward curve so the tree appears to have roundness. Lift off as you near the end of the stroke. When a stroke works well, do not go back and try to improve it. This technique takes a bit of practice, but it is easy to get the feel of it. Use mixes of white with orange, blue, and purple.

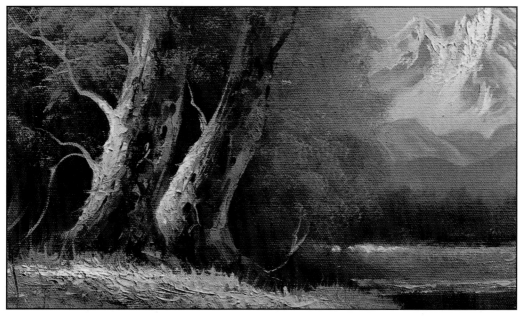

This wider view shows the combination of grass, weed, and bark textures. Once the trunks are completed, it is fun to go back in with the tip of a small knife and make holes, knots, and crevices in the trunk surface. Notice the strokes in the foreground grass. This thickness of paint is helpful in establishing form.

Boards and Fences: Boards can be painted several ways. One of the easiest methods is to load the side of the knife and create a board effect by moving the knife sideways. Once the board is formed, drag the knife vertically to create texture and character in the board. Use different colors for the base, adding lighter and darker colors for effects. Practice this method of making boards before going on to more detail.

Paint cracks with a mix of burnt umber and ultramarine blue. Load the side of the knife and use it in a slicing manner. This will make dark cracks and holes. Use the same technique to paint highlights on the left of the cracks.

Different values and colors are used to create the illusion of light playing on the face of a board. Using a small knife, combine side strokes with vertical pulls to apply and blend color.

This technique begins by painting an area for fence boards with basic colors and values. Blend light effects as if the area was one big, solid wall. Once light and color are placed, create boards by painting the cracks between them. When completed, place highlights on the edges of some boards for depth and reality. For more realism, vary the width and intensity of dark color between the boards, and gray the color a little here and there.

The illustration above shows the variation of width, darkness, and grayness in the boards and cracks. With very little paint on the edge of the knife, place highlights on the top edge of the boards using light slicing strokes. Next, using the tip and side of a small knife, place some detail on the larger boards. If they are large and show no wood grain at all, they will appear incomplete and amateurish in technique. Use your best drawing skills even with a knife.

Painting Rocks

Rocks play a magical part in painting, especially in seascapes and mountain scenes. They can be small, rounded, and smooth, or large and jagged. Many rocks at the seashore are rough and jagged because of water erosion or mineral composition. Others are rounded and smooth for the same reasons. High mountain glaciers and the action of streams also grind rocks smooth over long periods of time.

The following steps are an easy way to begin painting rocks using a knife. First, paint a light background by mixing white, permanent blue, and burnt sienna. Then, block in the rock mass using burnt sienna, burnt umber, and the gray mix. Keep the mixture a little on the burnt sienna side for a warmer looking rock.

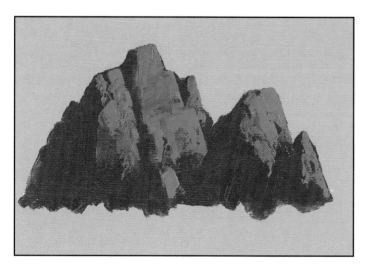

With a small knife, begin building the shape of the rocks using a mix of white, yellow ochre, and cadmium orange. Build from dark to light, using a side stroke to develop the face of the rock. This also begins texture. When painting rocks, always follow the angles of the planes. Notice how the rock begins to appear solid.

Next, use the small knife with white, permanent blue, and alizarin crimson to begin blocking in color within the shadow areas. Vary the value and warmth of the purple to make the shadows more lively. Purple is an extremely important color within shadows; however, try not to make it too bright and garish. Keep the values close.

Use a small knife to develop these shadows and make shorter strokes than you did in the last step. Short strokes give the illusion of texture within the shadows. Notice how the purple adds life to the subject. Mix a lighter blue and establish foam at the base of the rocks.

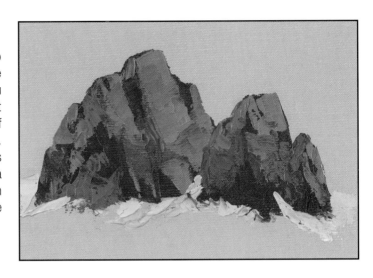

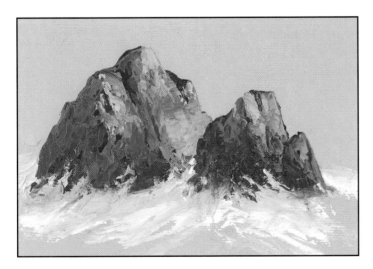

Use the small knife again to paint in the last highlights. Do not use pure white; it will appear chalky. Instead, use mixtures of white and a speck of cadmium orange in combination with just a speck of yellow ochre. Paint the lightest highlights with the tip of the knife to create a sparkle effect. Lastly, to set the rocks, add light to the water and foam at the bottom.

Smooth Round Rocks

These types of granite rocks vary in shape and size. They litter hills in some areas and are plentiful around many creek and riverbeds. Begin painting them by establishing the basic shape and size. Here, a mixture of white, burnt umber, and permanent blue is needed. This produces either a warm or cool gray depending upon how much blue is added. The more blue, the cooler the color. Paint the overall shape of these two rocks.

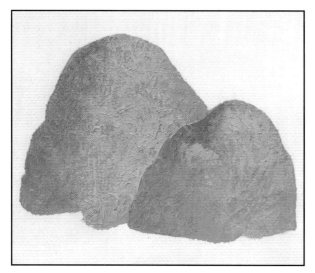

Next, begin modeling the form of the rocks by adding white and yellow ochre to the basic rock gray. Make small, flat tapping strokes as if patting or sculpting the rock. Strokes must follow the shape of the rock.

Once the forms are established, paint in the highlights using a lighter mix with a speck of cadmium orange for warmth. Use dot strokes to add to the texture of this type of rock. Paint rock cavities by dragging the tip of a small knife through the wet paint. This allows the dark underpaint to show through. Repeat this technique to make a few deeper holes in the rock. Place a few highlights next to the cracks and holes for depth. Add white and a speck of permanent blue to create life within the shadows.

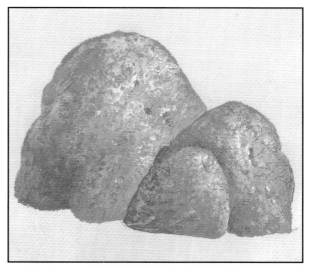

More Techniques

Using the Knife Point

Some knives have very sharp points whereas others are rounded. Each has its place of importance in knife painting. A pointed knife will not carry very much paint and is not a great tool for applying color from the tip. It is, however, a valuable tool for digging, picking, and scraping away color for special effects. At right are some samples of effects the sharp-pointed knife can create. Many others may be found with experimentation.

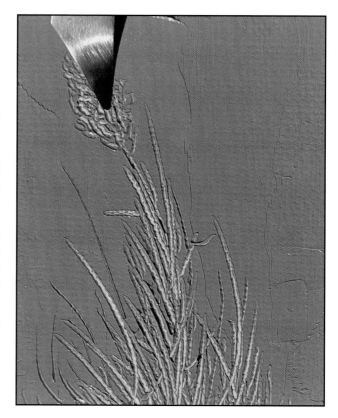

The samples at right were made with a round-tipped knife. They are slightly thicker than those made with a sharp-pointed knife but are equally important in knife painting.

By turning the knife in the fingers, a variation of widths and line shapes are possible. These can be used for such things from cracks in plastered walls to wood grains and bark texture. Be creative with a knife. Don't be afraid to try something new!

The point can also be used for scratching in textures such as crosshatch.

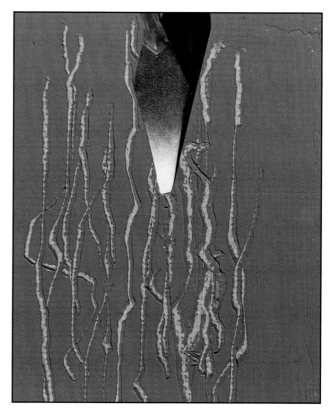

Plaster Wall

Mix a variety of values using white, cadmium yellow, cadmium orange, and yellow ochre. Paint them on loosely using the trailing edge of a medium-sized knife. Begin with the darker value, then loosely add the lighter. Allow some of the raw canvas to show. This helps create an aged look to the plastered wall.

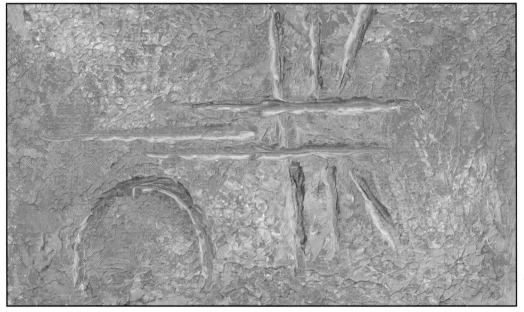

Granite Petroglyphs

Roughly apply several colors and values to make a general rock color. Add texture by patting the flat of a knife to the surface. Then scrape out some areas to begin the petroglyph forms. Use the tip and paint in highlights and shadows along the edges to create the effect of petroglyphs (a technique similar to the fence boards).

Blending Wet-On-Wet

Here, different color mixes are painted on top of one another and blended slightly. This is a wonderful method for creating a solid look in a large area of a painting. It can be used as a background for still life drawings as well as portraits. Try different combinations of colors. Remember, this type of soft background painting should always be supportive in nature, not gaudy. If background colors become important enough to catch the eye, they become the subject rather than a supportive background.

Paint a thin, very light colored background with a mix of white and permanent blue. Load the flat side of a knife with a little darker mix. Place the knife against the canvas in such a manner that the raised leading edge is downward. Begin a horizontal motion similar to the sawtooth stroke while dragging the knife downward. This creates a nice blending of color and is also a simple suggestion for the surface of calm water.

Still water reflects images like a mirror. However, even a slight surface movement will break up the reflection and create a subtle pattern of colors and values. Establish the basics of the water surface with white and permanent blue. Then, using the side of a large knife, paint a reflection with downward strokes. Next, paint small, horizontal ripple effects over it using a smaller knife and lighter colors. Try to feel the rhythm of the water as it moves. Do not overwork the strokes or place them too closely. Water painted using this technique can create a very soothing and peaceful feeling.

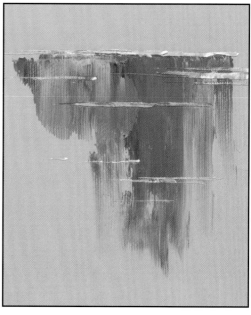

Painting Trees

Pine Trees

It is easy to paint both broadleaf and coniferous trees with the knife. Begin with distant pine trees. Apply a mix of permanent blue and white for a sky background. Next, mix equal parts of permanent blue and yellow ochre to a soft green. This is the basic mix for distant pine trees. Next, mix a little sky blue into the tree mix to make them recede. Then load the side of a small knife and paint vertical strokes to indicate distant pine trees.

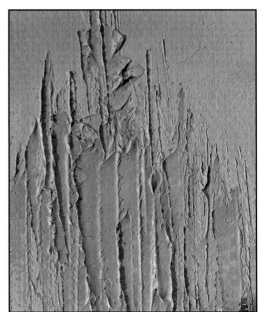

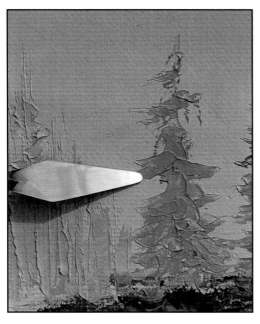

Blend the distant trees slightly into the wet sky base. The more sky color you add, the more distant they appear. Use the tip of the knife to add horizontal strokes to suggest branches. Add detail as you move forward.

Make tree masses darker and greener as they come forward. Paint a few closer trees adding some boughs to indicate detail. Next, mix two parts burnt umber to one part pthalo blue for a blackish green.

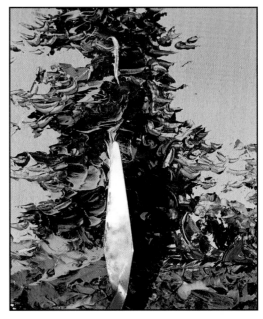

Paint in a small foreground tree using the tip of the knife. For highlights, add a bit of cadmium yellow light to the basic tree mix and use the knife tip to paint a suggestion of light on the left side of a few trees. Place a mix of white, pthalo blue, and alizarin crimson on the shadowed side of the trees (not all of the trees!). Finally, spot a little burnt umber and cadmium orange in the foliage to indicate trunks showing through here and there. Draw branches using the small knife tip.

Broadleaf Trees

Broadleaf trees are less rigid in their form than pine trees, but each type of tree has its own shape. At right, a general looseness is painted to indicate the foliage of broadleaf trees. Use mostly the tip of the knife with this technique. Change colors often and attack the canvas at different angles to create the abundance of foliage.

Notice the introduction of warm colors to create color interest within the foliage.

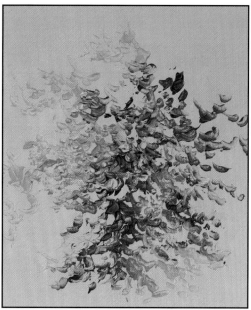

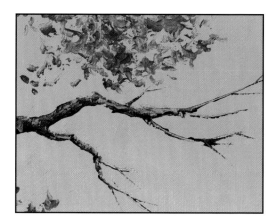

To draw branches use the tip of the knife. Make long strokes, stopping and changing direction to give a natural look to the branches. Twigs are made with a small-pointed tip. Make lighter twigs by scraping out color. Use the point and edge of a small knife to create highlights within the branches and twigs.

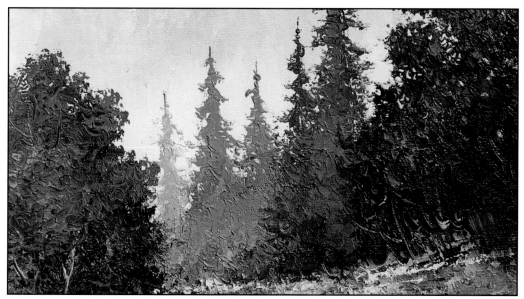

Above, a combination of broadleaf and coniferous trees are shown in the same setting. Light background color was mixed into the distant trees to create atmospheric (aerial) perspective. Notice how dark the color is on the right foreground tree.

Painting Seascapes

Painting seascapes and marine scenes with a knife is great fun. Techniques vary considerably, ranging from a rough application of paint for textures such as rocks to smooth, gentle blends for mists and foam. The following exercises focus on some important elements in seascape painting and the techniques used to paint them.

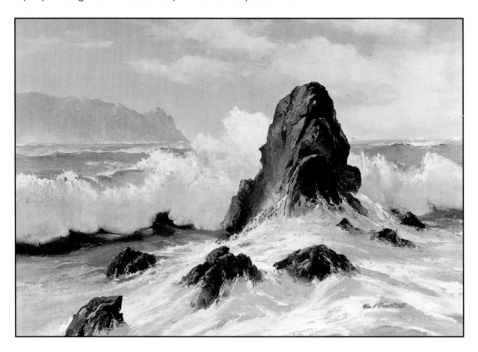

Sky and Backwater

With any painting, the sky sets the mood for the scene. A stormy sky requires a different palette of colors than a bright, sunny day. The sky and light source also affect the colors used in the water. For this exercise, *Whipped Cream*, a palette of colors to indicate afternoon is used. The light source originates from the high left.

To begin this exercise, paint a simple sky using a mixture of white and ultramarine blue to the value shown. Use a medium-sized knife and keep the texture fairly smooth. This blue is warm, making it excellent for an afternoon sky. Paint a horizon haze using white and a speck of alizarin crimson. Use a sawtooth stroke (page 14) to blend. For the backwater, mix a combination of equal parts of ultramarine and cerulean blues.

This combination makes a "fake" cobalt blue that is rich and controllable. For a warmer blue, add more ultramarine. This makes the mix deeper and more purplish because of the red in ultramarine blue. For a cooler blue, add cerulean. Cerulean is a greenish blue and does not contain the red that ultramarine does. Lighten this blue with white to change value.

Paint a thin layer of this color over the entire area. Keep the horizon line straight and parallel to the top and bottom of the picture plane and blend the hard edge slightly. Wave forms will be painted into this wet backwater area. Use the same color and paint in the basic form of the headlands. Use a scrap of canvas to practice these strokes.

Next, mix white and Naples yellow and white with a speck of alizarin crimson. Use the small knife and add detail to the headland mass. Make long curving "pulling" strokes (as shown) to create the waves in the backwater. Blend this color along the top of these strokes leaving a hard edge at the bottom. This builds form in the waves. Notice how this color is also used to build the form of the major wave.

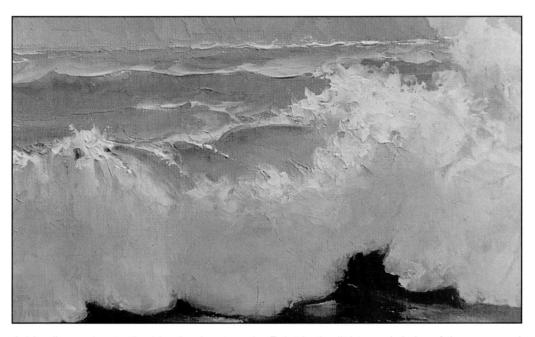

Add yellow ochre to the blue backwater mix. Paint in the lights and darks of the wave and foreground water. Add more blue to darken. Add ochre and white to lighten. To block in the crashing foam mass use white, ultramarine blue, and a speck of alizarin crimson. Paint the shadow areas, and then place the lighter highlight colors (mixes of white, Naples yellow, and alizarin crimson) over them. Add white with a speck of cerulean to the bottom of the foam.

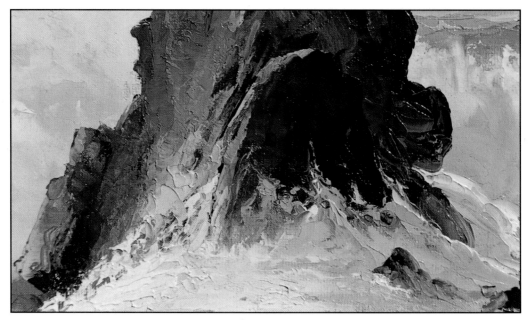

Paint the dark rock base using a mix of burnt umber and alizarin crimson. Then overlay the lighter colors for shape and form. Gray is white with burnt umber; orange is Naples yellow with a speck of alizarin; and yellows are pure Naples yellow and Naples with white. Begin the foam using white with cerulean and white with backwater blue.

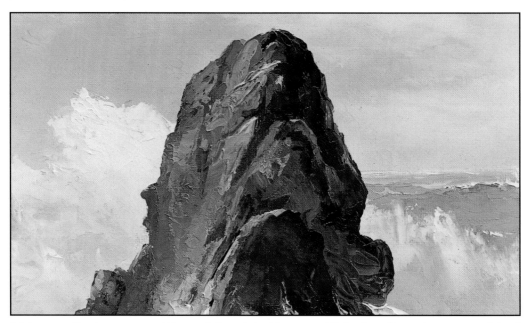

Make sure the foam around the rock is painted to your satisfaction. It can be accomplished later, but is much easier to complete before painting the rock over it. Notice the loose application of the gray mix in the top area and how it is applied to suggest openings and cracks in the rock face. Try not to blend these lighter colors, otherwise the rock will become smooth and appear out of place. Notice the foam and waves on the right.

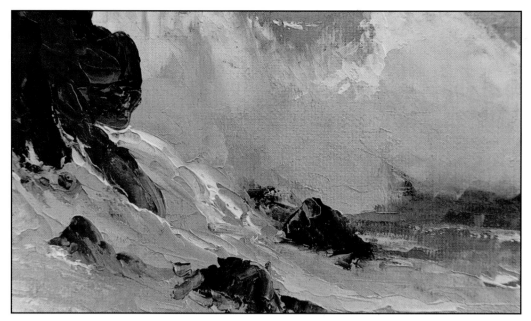

This close-up shows the wave detail and small rocks that are in the shadow on the right side. A great variety of strokes are used to accomplish this area. Pulling strokes are combined with side strokes. Long and short strokes are combined with straight and curved strokes. Stroke variation adds excitement and reality to the scene.

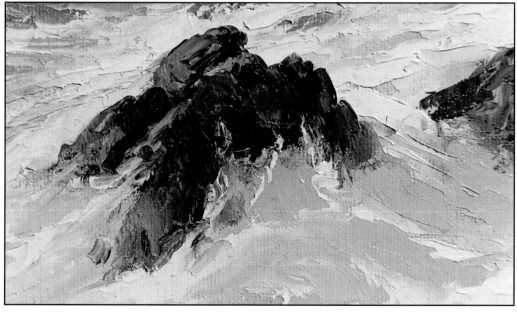

Here, the detail of the rocks in the left front are shown. Paint in the foam patterns first. Then, place the basic rock forms using burnt umber and a speck of alizarin crimson. Next, paint the rock features with the same lighter mixes used previously. Finally, paint in the highlights, shadows, and details to bring the scene to completion.

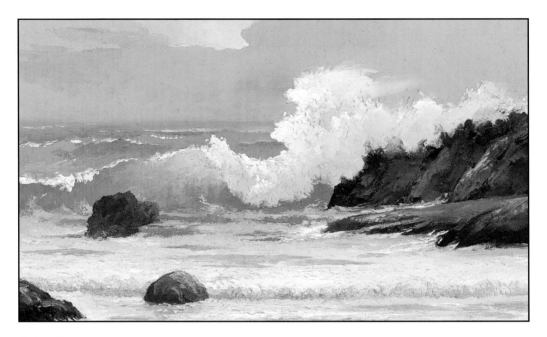

Quiet Evening

The mood of this painting is one of quietness. With the rolling surf and foam, some action exists in the painting; however, the colors indicate a quiet mood. The wave anatomy is not so dramatic that it contradicts the color mood. Begin by sketching the subject onto the canvas. Then, use the color mixing chart shown below to create the painting from back to front. Use the larger knife to lay in the basic colors and then a smaller one to smooth, blend, and create final details. Progressive steps are shown on the facing page. Notice how thickly the paint is applied. This allows for enough manipulation and blending. With each blend, some of the paint is removed. Make sure that you have enough pigment at the beginning.

Mix a supply of the major numbered colors with the knife. Other colors are blends obtained by mixing the major colors with each other and with other pure colors such as white and yellow. Because colors vary slightly among manufacturers, try to match the value of the colors (lightness and darkness) as closely as possible. In opaque and knife painting, apply the overall base color of an area (known as the local color) and then build darks and lights into this basic color.

Blending is done with a clean knife. Make a blending stroke, wipe the knife, make a blending stroke, wipe knife, and so on. When blending, it is important to wipe the knife between each stroke to keep the colors crisp and clean.

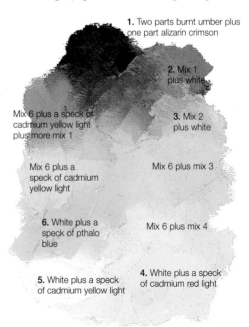

1. Two parts burnt umber plus one part alizarin crimson

2. Mix 1 plus white

Mix 6 plus a speck of cadmium yellow light plus more mix 1

3. Mix 2 plus white

Mix 6 plus a speck of cadmium yellow light

Mix 6 plus mix 3

6. White plus a speck of pthalo blue

Mix 6 plus mix 4

5. White plus a speck of cadmium yellow light

4. White plus a speck of cadmium red light

Using the color mixes on the blending chart, block in the shapes of the clouds, sky, and horizon. Apply a lot of paint so that it can be blended later. Make the knife strokes follow the pattern shape of the clouds and sky. Always wipe the knife clean before going back to the palette for fresh paint. Make subtle blends within each area. Then use a clean knife and blend in the desired detail.

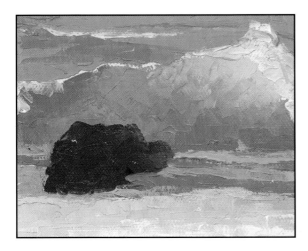

In this step, mix several values of gray, then paint in the backwater. Mix the dark and light greens, pulling them into the backwater where shown. Blend here and there slightly.

Use the two greens to create the form of the curling wave. Make the glow (eye) of the wave using the lighter green. Once you have the basic colors established, mix several values of gray and begin painting the crashing and flat foam. Also place some of these grays in the backwater.

Here, the basic shapes of the foam and rocks are developed. Paint in the darker colors in each area first, placing the lighter colors over them.

Paint in the rock areas with color #1. Then, use color #1 with white to develop the basic rock shapes. Use lighter colors for highlights.

Spot color #6 here and there in the foreground foam. Then use color #5 with white for the final foam highlight.

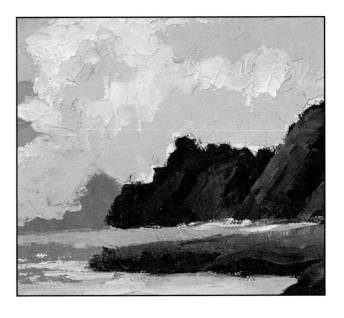

Painting Skies and Clouds

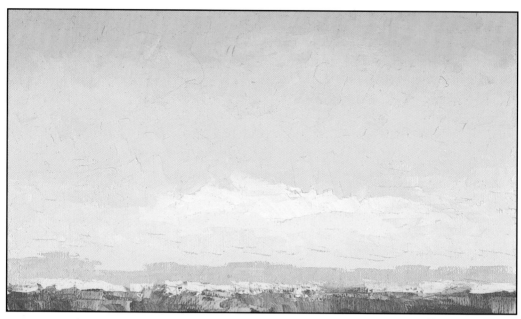

Use these color mixes to lay in the basic colors. Make loose strokes wiping the knife clean between loads of color. Position the elements in the composition.

White plus cadmium yellow light — White plus alizarin crimson — White plus permanent blue — Other mixes plus burnt umber

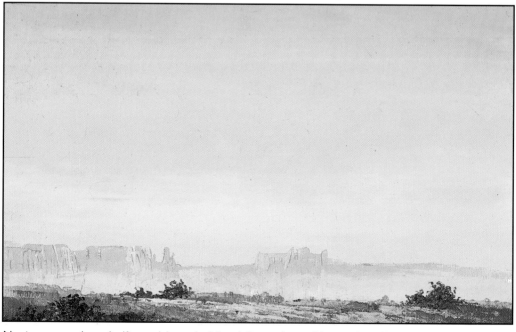

Next, use a clean knife and loosely blend the colors. Shape the distant buttes and foreground. Place highlights using sky colors. This original painting, *Distant Buttes*, is small—only 8-1/4" x 5". It is a misconception that all knife paintings must be huge and roughly done.

Afternoon puffers (*cirrus fibractus*) are high ice clouds that usually indicate good weather ahead. Paint a thin layer of white and cerulean blue to represent background sky. Mix white with a speck of cadmium orange for the cloud forms. Add some of this cloud mix to the bottom of the sky for a soft gradation of value. Place cloud forms loosely.

Use the teardrop-shaped knife, or one similar, and gently blend the cloud masses. Make strokes from lower right to upper left, lifting the knife off the painting surface without stopping. (Stopping during a blend leaves a distracting mark.) Wipe the knife after each stroke and avoid overblending.

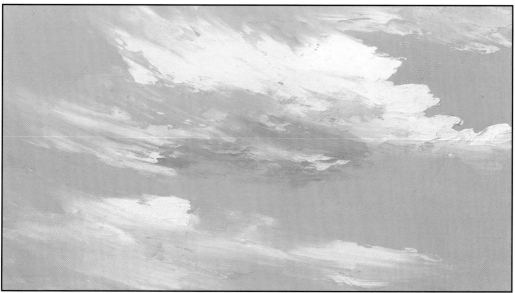

These clouds are painted in the same way as those explained above; however, a little burnt umber is mixed with some sky color for the gray shadows. Use the tip of the knife to form the definite rounded shapes on the right side of these clouds to indicate movement.

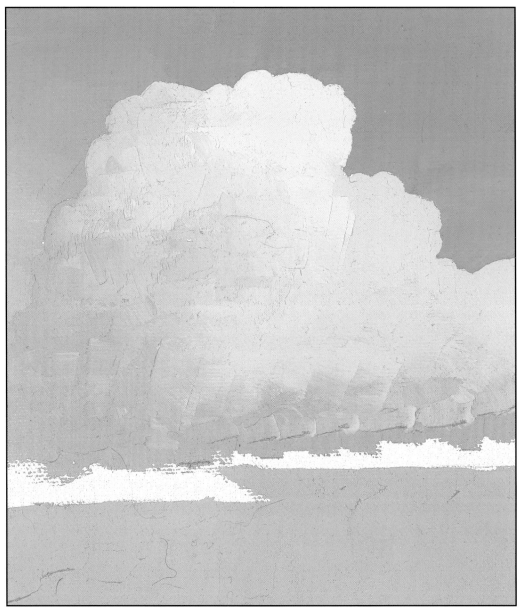

Cumulus clouds are beautiful and easy to paint. Follow these easy steps and watch them develop.

First, draw in the basic cloud form. Then, paint the upper sky with mixtures of white, cerulean blue, and ultramarine blue. Add a little more ultramarine blue in the top right corner of the sky. Add more cerulean and white as you move downward. This creates an illusion of horizon light and adds to the atmospheric feeling of the scene. Paint white, cerulean, and a tiny speck of alizarin crimson in the sky below the cloud. Gray all of the sky colors with a tiny speck of cadmium red light.

Next, mix a light value of white and cadmium red light. Paint the light portion of the cloud and mix it with sky blues to paint the shadow area. Apply all of these colors in a fairly thin layer to make it easier to paint other colors over them.

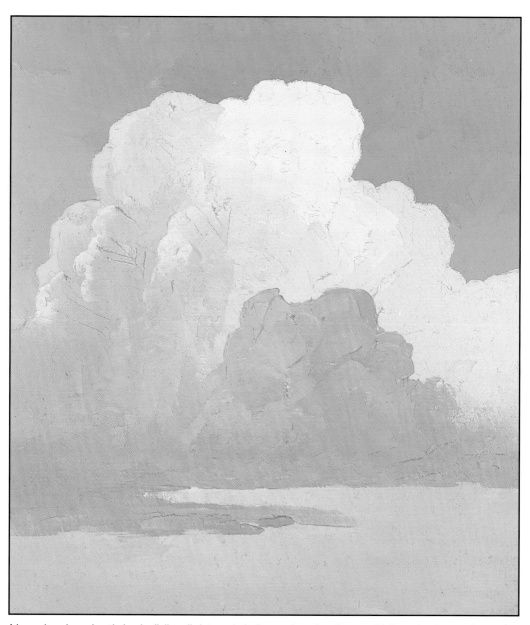

Now develop depth by building light and dark overlapping forms. Using shadow color, paint in the little, dark cloud and notice how it appears to be in front of the large, lighter one. Mix a tiny amount of pure ultramarine blue, cadmium red light, and a speck of alizarin crimson together; use it to darken the shadow color. Darkening too much will cause the cloud to appear threatening. Use the small knife to lightly draw the little, dark finger cloud at the bottom. Add a mix of white and a speck of alizarin crimson to the sky around this area. Blend the colors to create soft shadows along the entire cloud bottom.

Using a much lighter mix of white and cerulean blue, begin to paint in some of the details within the shadow side of the cloud. To make clouds—and any other subjects for that matter—believable, pay attention to detail within the shadows.

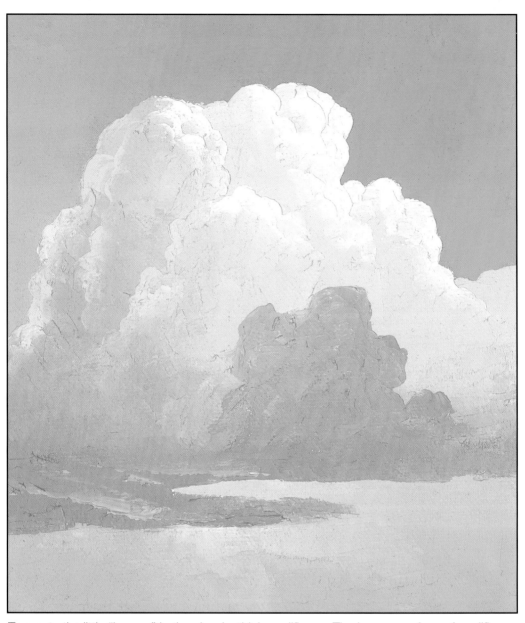

To create the little "bumps" in the clouds, think cauliflower. The bumpy surface of cauliflower somewhat resembles a cumulus cloud. It can be a subtle reference by placing it in a light setting (similar to the scene being painted). A cumulus cloud form is a dense formation that has a horizontal base and a top that is shaped by piled up, rounded masses. Using the small knife, let the paint flow from the tip while making small curved strokes. Work from the outside of the cloud inward, overlapping and changing the shape, size, and placement of the clouds. Add more alizarin pink in the lower sky.

Continue using the white and cerulean blue mix for details in the shadow side. For the sunlit side, mix white with a speck of cadmium yellow light for these "bumps." Make the same kinds of strokes as before on the shadow side, only in reverse.

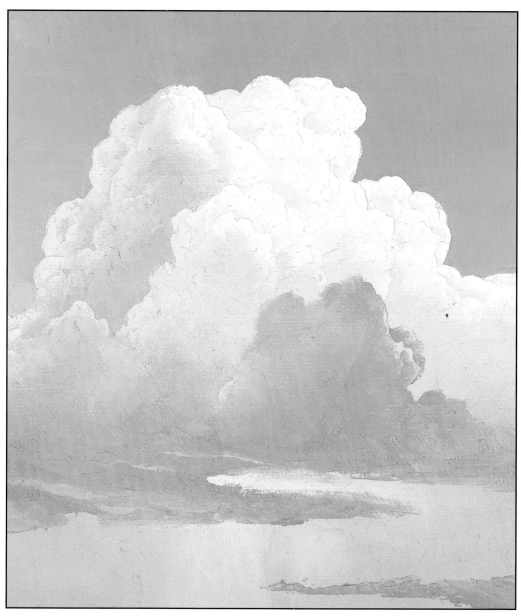

Using smaller strokes, continue to build the masses, shapes, and forms in the cumulus cloudscape. Moving into the center of the major cloud mass, blend the colors together a bit more smoothly than in any other cloud areas. Build up the light on the sunlit side until it becomes the dominant area of light in the scene. Add a touch of sunlight color to the cerulean mix in the shadow area. Finish the pink alizarin glow in the lower sky and then create the little drifter at the lower right. Keep values delicate.

Paint in some subtle hints for texture on the underside of the cloud using the alizarin pink mix. Use some of the cerulean mix to place subtle forms on the small, dark cloud. Hold the knife lightly when applying detail, otherwise the delicate tiny blends needed to finish the painting will be impossible. Try another scene using these techniques.

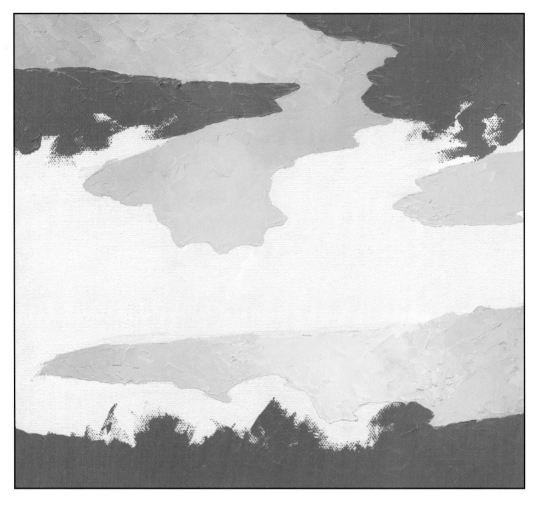

Sunset Glow

The original painting for this exercise is small—it's only 11" x 9-1/2". In these exercises, the strokes are fairly loose so that details of the paintings' development can be seen. Contrary to common belief, knife paintings do not have to be huge.

Begin this painting by using the color swatches at right as a mixing guide. The dark cloud undercolor is shown on the next page.

Block in the overall scene, as shown, using a medium-small knife. The same approach used to paint the previous exercise can be used here. At this stage, keep the paint application rather rough.

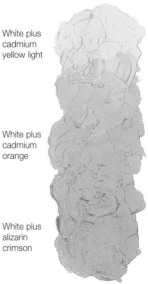

White plus cadmium yellow light

White plus cadmium orange

White plus alizarin crimson

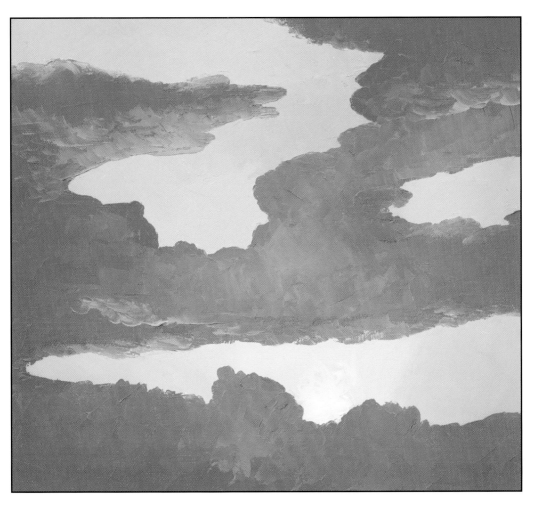

When color is added, it builds. As it is blended, paint is removed from the surface, so be sure to apply enough paint to last through several blends. Blend the background sky a bit before finishing all of the cloud masses. Add pure white, as shown, to indicate the light glow behind the clouds. When finished with this area, continue painting in the dark clouds.

Then use a red-orange blend to apply some of the light areas. As you create this light glow within the clouds, also begin to develop some of the physical form on the underside that catches light.

Load a small knife on one side (as with small waves on page 31) and make pulling strokes. These small pulling strokes suggest cloud texture.

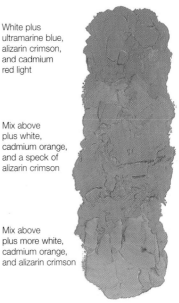

White plus ultramarine blue, alizarin crimson, and cadmium red light

Mix above plus white, cadmium orange, and a speck of alizarin crimson

Mix above plus more white, cadmium orange, and alizarin crimson

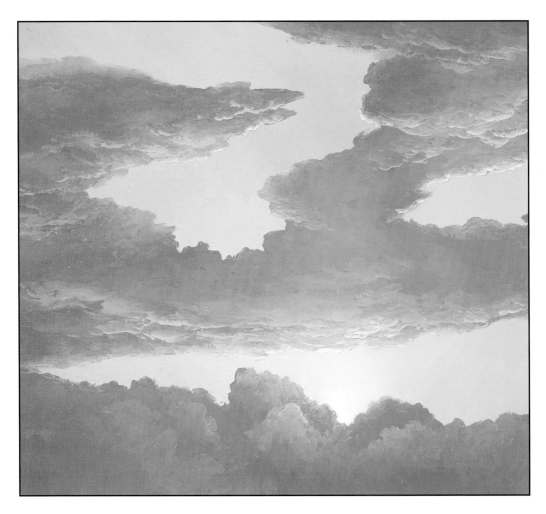

The outside border of the stroke remains hard edged while the inside is blended slightly. This creates depth in the texture. Occasionally, change the position of the knife by making a side stroke, allowing the paint to flow from the knife tip. This integration of stroke techniques creates interest in the work. Paint in all remaining detail and work toward the white and cadmium yellow mix. Use a spot of pure white for highlight.

For light play and drama within this type of cloud formation, work from dark to light. Gradate from dark to light slowly. To obtain drama and brilliance of color, place warm, lighter, fresh colors over gray, darker background colors. This is the color principle used to create this sunset painting.

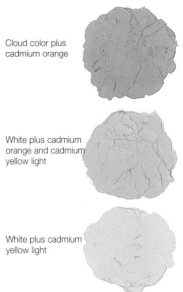

Cloud color plus cadmium orange

White plus cadmium orange and cadmium yellow light

White plus cadmium yellow light

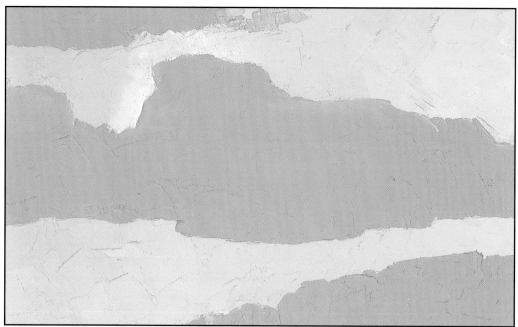

Halo light effects create wonderful drama in a cloud scene. Use these mixes and block in the sky and cloud.

| White plus cadmium yellow light | White plus a speck of cadmium red light | White plus cerulean blue | White plus ultramarine blue | Mix at left plus cadmium red light |

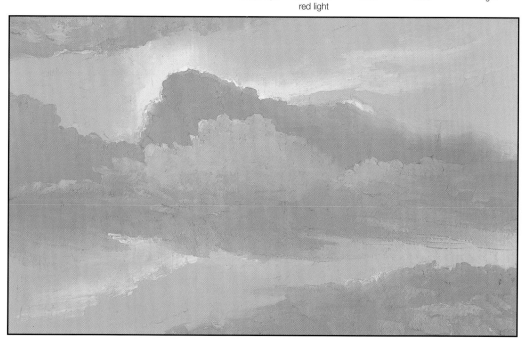

Using the colors above and the techniques learned in the last two exercises, paint in the details of this scene. Build the lighter cloud into the dark mass with the cerulean blue and cadmium red light mix. Paint and blend in the halo glow in the sky before applying the final cloud highlights. Using a small knife, work from dark to light to build final textures.

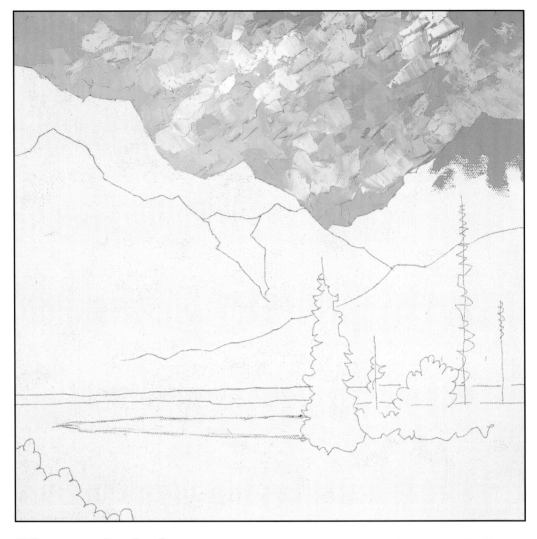

Mountain Lake

This painting exercise is divided into four steps. Begin with the sky and follow the steps carefully. Smooth out the paint textures to the desired degree, but remember that some of the charm of a knife painting is the texture. It is best to smooth and blend each area to satisfaction before continuing; it is difficult to go back and smooth colors after another area has been painted around or over it. Refer to the completed painting for depth of final texture. I prefer texture in some areas and less in others. Texture helps form shapes and makes the painting interesting to view. Use the color mixes at left and block in the atmosphere of the sky. In this sky, keep the final blends loose for color and mood.

White plus ultramarine blue, a speck of burnt umber and cerulean blue

Mix above plus white and a speck of cerulean blue

Mix above plus white and a speck of cadmium orange

White plus a speck of pthalo red rose

White plus a speck of cadmium orange

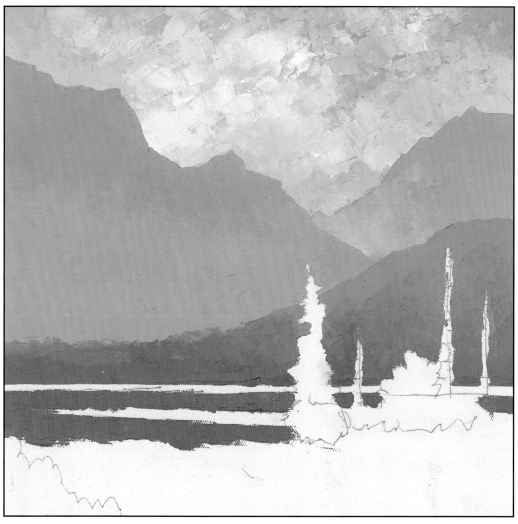

Before using the colors at right to develop the mountain range, refer to the final painting and blend your sky to a desired smoothness. The texture of the sky should be a bit smoother than the mountains. This texture creates depth and atmosphere. Mix more sky colors into the distant mountains and less as they move forward in the scene.

Paint in haze at the base of each mountain to add to the aerial perspective. Establish the dark green land and then refer to pages 48 and 49 to finish your mountains while the underpaint is wet; otherwise, blends are impossible. Use the sky colors to develop the structure of the mountains, working from dark to light. Do not blend the strokes that make up the mountain face and texture.

White plus ultramarine blue, specks of burnt umber and pthalo red rose

Mix above plus white and specks of ultramarine blue and pthalo red rose

White plus ultramarine blue and specks of burnt umber and cerulean blue

Ultramarine blue plus yellow ochre and a speck of white

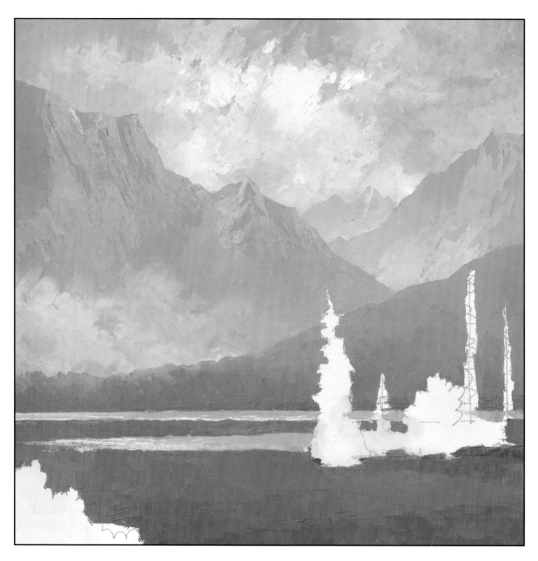

Follow the steps on these two pages to complete the painting. Use the color mixes on page 49 to finish the foreground and trees. Work from dark to light when building these tree forms. Paint in the grass using the light yellow-green, and enhance the glow area with a touch of pure cadmium yellow light here and there.

Paint the mist at the base of the mountains stronger than desired; it will fade a bit during the blending and smoothing stage. Establish and blend all of the haze areas first, then pull the snow and mountain face colors down into them. Block in all of the foreground undercolors, making them appear a little darker in the very front and a bit lighter toward the back. Paint in the water with white and ultramarine blue, and then apply the lightest sky colors into them as reflections. Notice how the snow masses fade as they move down into the mists and haze. Develop the outline of the distant trees; then blend all areas to desired satisfaction.

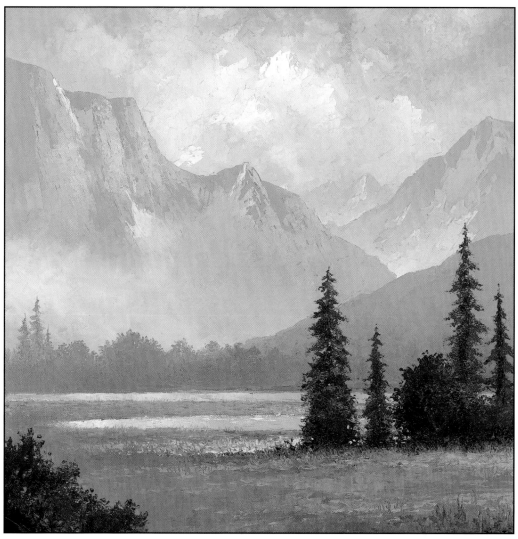

Mix burnt umber and pthalo red rose for the fall colors on the bushes. Highlight with white and a little cadmium orange. Draw the suggestion of branches using the tip of the knife and a lighter mix.

Use the second color for the dark base of the trees, then highlight with cadmium yellow light and a little ultramarine and cerulean blue. Spot some of the bush colors into the trees to tie everything together. Use the tip of the knife for small details.

Paint in all of the highlights and bring the painting up to individual preference. Keep the colors a bit grayed, as seen in the swatches, so they are not too harsh. Harsh colors ruin the mood of this soft, quiet scene.

White plus ultramarine blue and specks of burnt umber, pthalo red rose, and cerulean blue

Ultramarine blue plus cadmium orange

Mix above plus cadmium yellow light

White plus cerulean blue and a speck of cadmium yellow light

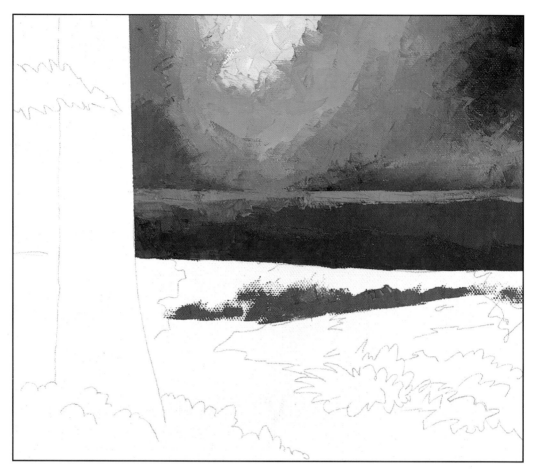

Forest Glade

Mix the colors at right, and use them to block in this portion of this scene. There is a rich feeling of green in this painting; it adds to the flavor of lush forest growth. Try to avoid making any greens too raw, because they will appear false and without depth.

Begin by lightly sketching the subject on the canvas. Then use the color mixtures to lay in the undertones. As before, always refer to the finished painting to bring each area up to a satisfactory final before going on to the next portion. Once the painting surface has dried, it is difficult to apply any smooth color layers and blending into the undercolor is impossible. If this should happen, simply rewet the undercolor and proceed from there.

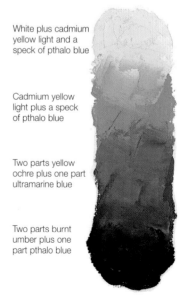

White plus cadmium yellow light and a speck of pthalo blue

Cadmium yellow light plus a speck of pthalo blue

Two parts yellow ochre plus one part ultramarine blue

Two parts burnt umber plus one part pthalo blue

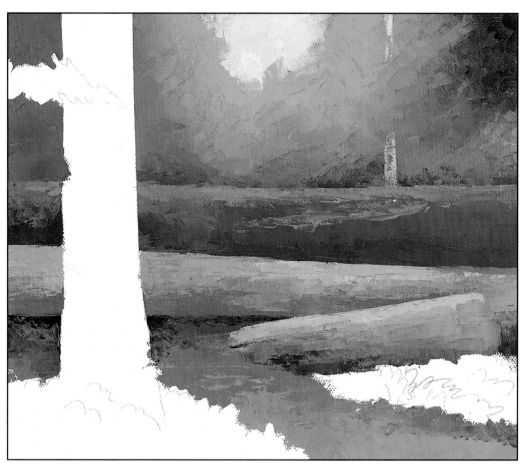

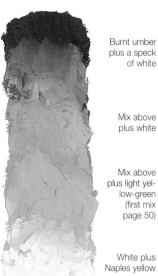

Burnt umber
plus a speck
of white

Mix above
plus white

Mix above
plus light yel-
low-green
(first mix
page 50)

White plus
Naples yellow

Continue using the color mixtures from the last step and block in more of the undercolors. Use pure yellow ochre for the warm spot of undercolor. A small pond will be painted in this area, which requires a warm undercolor to support it. When knife painting, you do not know if the paint will remain smooth when applied, so you need to make sure there is a sufficient foundation of color before any final color is painted in.

Using the mixtures at left, begin forming the shape of the fallen tree trunks. Add some of the green colors to create a feeling of uniformity throughout the entire painting. Add a little more green to the log colors and establish the foreground. Adding more yellow and warm brownish colors gives the feeling of ground.

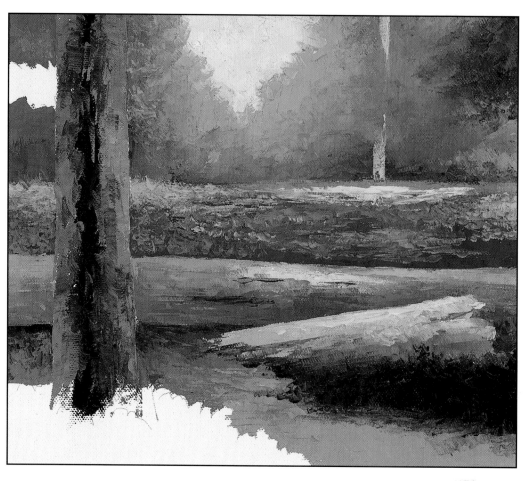

Begin establishing more detailed textures, such as grass and tree trunks. Use the final painting as a guide and create the textures while the underpaint is still wet. Use the small knife and make flat upward strokes. Lift the knife off the surface, allowing the paint to apply in an irregular manner. This creates the illusion of grass.

For the logs and bark textures, make more controlled strokes to create a pattern that follows the length of the trunk. Apply the cooler blue-green color over the warmer undertones. Use the top mixture for the bright sunlit glow in the distant middleground. For harmonious blend, add the purple to the basic log colors for the shadow side of the tree.

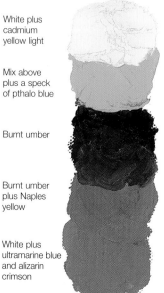

White plus cadmium yellow light

Mix above plus a speck of pthalo blue

Burnt umber

Burnt umber plus Naples yellow

White plus ultramarine blue and alizarin crimson

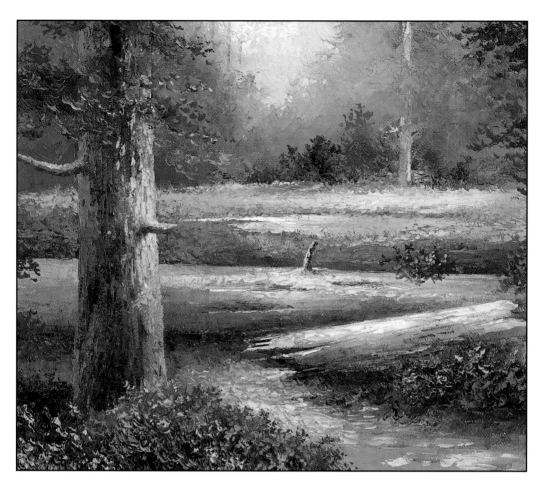

Now it is time to place the final details. Most of these have been created as the painting developed and should be nearly complete. It is now a matter of bringing them to a complete painting.

Individual preference dictates how much detail to put into this painting. Some artists like a lot of detail, while others prefer little detail. All areas have been left semirough to show the methods used to develop the work. A much softer final can be created by simply blending the colors a little more thoroughly than shown here.

Add the pond by using white and a speck of pthalo blue. Develop the reflection on the left side using the lighter yellow colors and, finally, a touch of white on the very thin, left side. Add a little yellow for the green in the middle and keep the mix pure light blue on the right.

White and Naples yellow in varying degrees of mixes are used for the final texture on the tree trunk, fallen logs, and foreground.

Dark leaf, bough, and grass masses are painted in with the dark burnt umber and pthalo blue mix, and then they are highlighted with lighter greens. Use the knife tip for this task. Add cadmium red light to the burnt umber mixes and block in the final colors and shapes on the bushes using the knife tip. These little bushes add color, contrast, and warmth.

White plus
Naples yellow

White plus
cerulean blue

White plus
cerulean blue
and a speck of
pthalo red rose

White plus
cerulean blue
and cadmium
orange

More white
and cadmium
orange

More cerulean
blue and pthalo
red rose

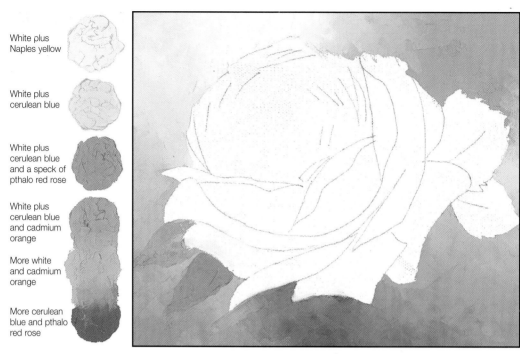

Roughly position the basic background colors using the combinations of colors shown at left. Once they are in place, gently blend with a clean knife. Wipe the knife clean after each stroke. This keeps the colors and blends fresh. Press lightly when blending.

White plus
pthalo red
rose

Plus more
white

Plus more
white

Plus a
speck of
cadmium
orange

Naples yellow
plus cerulean
blue and a
speck of
burnt sienna

Plus more burnt
sienna and
cerulean blue

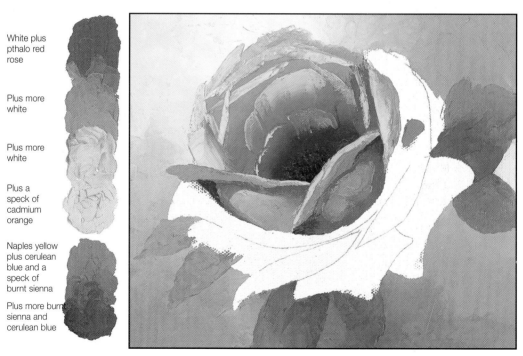

Next, begin the petals. Use the blended mixes at left as a guide for developing each petal. Rough in the back petals, blend them, and then work toward the front. Paint forward overlapping petals last. Make final blends with a small knife.

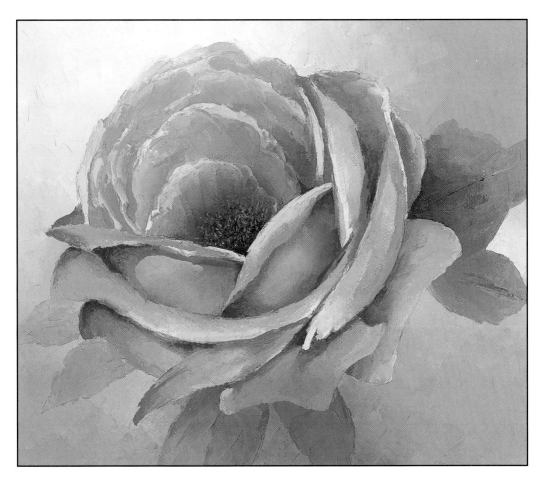

Flower

Use a small knife and work the blends of each leaf as you go. Place lighter colors over darker, keeping the value differences soft. The various colored leaves are combinations of these mixes. Add a touch of the background color to some of them. This allows them to recede, providing a feeling of depth and softness. Continue building more leaves until you have as many as you like. Only a few are painted in here so you can see the various blends in the background against the colors of the flower.

Smooth the painting to the desired degree, but don't over do it. Oversmoothing not only takes the life out of the knife painting but also depletes its special look and feeling.

After the dark area in the flower depth has been painted in, use the tip of the knife and scrape out a textured pattern to represent the stamen and pistil.

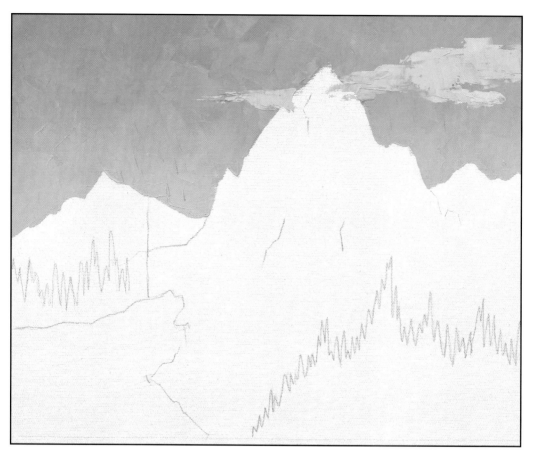

Mountains

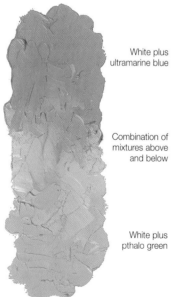

White plus
ultramarine blue

Combination of
mixtures above
and below

White plus
pthalo green

The theme of this painting, *Living on the Edge*, centers on the tree perched on the ledge. The hard-edged detail of the tree against the soft background mist creates scenic depth. Overlapping objects, misty haze effects, and close value changes all add to the atmospheric feeling within the painting.

Begin this exercise by first drawing in all the elements of the scene. Then, using the color swatches at left as a guide, block in the main colors of the sky with a medium-sized knife. Use more of the ultramarine blue and white mix in the upper left corner. As you move to the right, add more of the pthalo green mix. Also, as you bring the colors down to the horizon progressively use more of the pthalo mix. Blend them slightly. Lay in the cloud mass using the pure white and pthalo green mix. Use the final painting for detail reference in this mountain exercise.

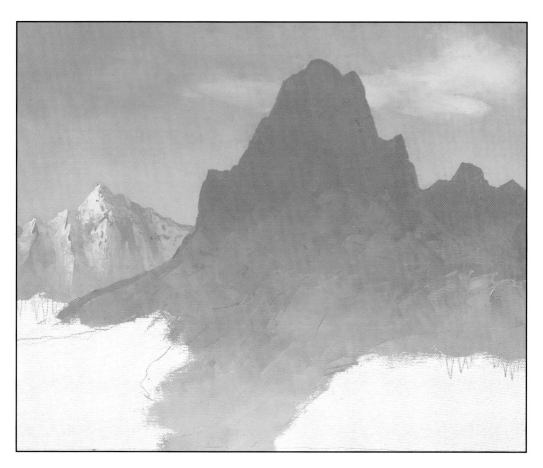

Next, gently blend the sky and cloud form. Use a larger knife to make this blend. Be certain to wipe your knife clean after each blending stroke to prevent color contamination. Next, paint in the form of the distant mountain on the left using the top color mix shown at right. Refer to the techniques shown in close-up views on page 58. Blend white and a speck of ultramarine blue at the base for mist. Then use pulling strokes to paint in the snow. Use the blue mix for shadow and the orange mix for sunlit snow.

Next, build the main mountain using the bottom color and a medium-sized knife. Point the tip of the knife toward the outside edge of the mountain to make a clean edge. Don't worry if a little ridge develops.

Next, set up a mist blend at the mountain base by adding some ultramarine sky mix as you work downward. Place the color horizontally using broken strokes. As you move lower, add the light pthalo green mix in the same way (see page 59).

White plus ultramarine blue and a speck of cadmium red light

White plus cadmium orange

Darker mix of white, ultramarine blue, and cadmium red light

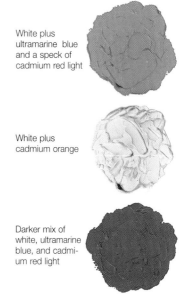

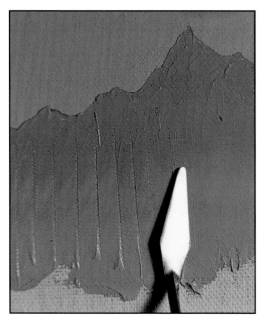

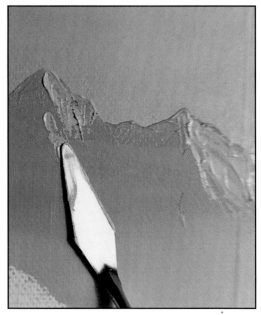

After the basic mountain form is placed, paint in some ultramarine blue sky mix using a sawtooth stroke. Then blend using a horizontal stroke to achieve the appearance of mist.

Once the mist is blended, use the sky color and pulling strokes to begin the shadow snow. Let the paint slide off the tip of the knife. A mountain often changes shape and grows slightly when snow is painted in.

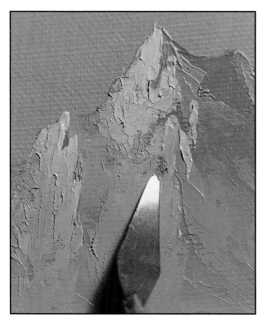

Add a little white to the orange mix and paint in the sunlit snow using the tip as you did with the shadow snow. Paint some areas a little more solidly to make a snow field or distant glacier.

Once the sunlit and shadow snow is placed on the mountain, blend the lower area slightly with a clean knife. Leave enough texture within the blend to create an illusion of detail fading into the mist.

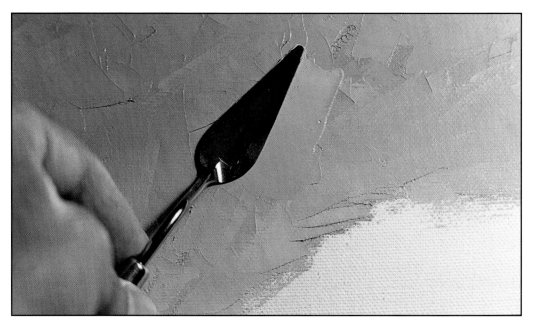

To build mist, loosely block in colors as shown. Lay them in horizontally using the white and ultramarine blue mix. Use loose strokes and vary the angle. While moving downward into the lower mountain areas, add the light green mix in the same manner. Keep all the colors fresh by wiping the knife between loads. Interweave the colors.

Once the colors are in place, gently blend using horizontal strokes. Again, wipe the knife clean between strokes to keep the colors fresh. Blend all the way up into the dark mountain color. It is important to make this blend one of the smoothest in the scene to create a believable haze against which to place the foreground objects.

The color swatches for these steps are located on page 61. Use a large knife and begin blocking in the sunlight mountain color (top mix). This step begins to create the features of the mountain face. Once this is done, the structure can be built upon by painting in sunlight and shadow snow. Use the middle mix on page 61 to paint in the shadow snow.

Now that the basic mountain structure and snow are started, paint in the distant ledge and trees using the bottom mix and illustration on page 61. Add the middle mix for the illusion of misty haze along the bottom and as the trees progress toward the left. Paint a suggestion of sunlit snow with the orange mix. Paint the trees using vertical strokes; push up and lift off to create pointed treetops (page 62). Paint a small light blue, snow-covered tree in the front.

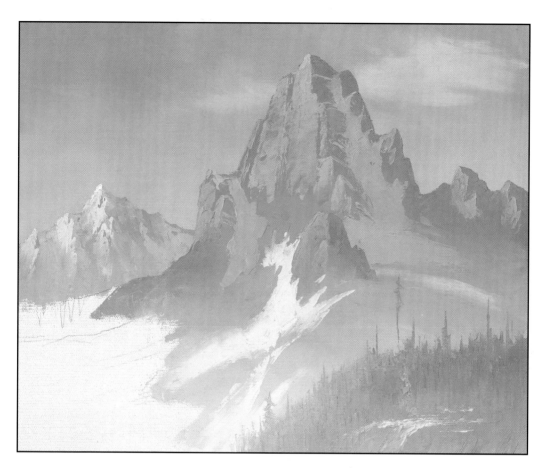

Continue building the mountain features using the warm reddish mix. Remember to apply this warm color only on the left (sunlit) side of the mountain. Create small peaks rising into the light with this color. Make knife strokes follow the shape of the face you are creating.

White plus cadmium red light and yellow ochre

Once you have the basic mountain features completed, begin painting in the shadow snow patterns that appear on the right side of the mountain. Use the middle value (white and ultramarine blue) for this. Occasionally, allow some of the basic mountain color to mix in or come through this color. This helps in "attaching" the snow patches to the mountain sides.

White plus ultramarine blue

Next, begin painting the sunlit snow in much in the same manner as the distant mountain. Begin a pattern that makes this snow also appear to cling to the mountain and rest in the crevices. Blend the snow colors as they move down into the bottom mist.

Mountain base color: white plus ultramarine blue, cadmium red light and mist color (white plus pthalo green)

Paint in small distant trees using the edge and tip of a small knife. Occasionally paint some detailed treetops to establish realism. Overlap the horizontal light orange snow mix strokes with vertical strokes. This not only breaks the monotony but also gives the illusion of snow among the trees. As the trees move toward the left, add more of the mist and sunlit snow colors. This makes them appear to recede.

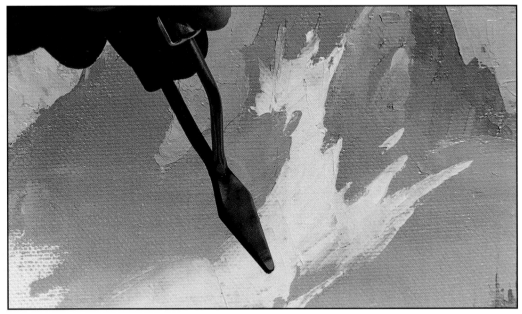

To create soft depth within the snow masses, blend the shadow and sunlight colors here and there. Notice how the soft blend suggests a deep snow pack within a massive open field on the side of the mountain. Allow the sunlight colors to sharpen as they move up the face of rocks and ledges. Soft-blended areas are mysterious, whereas hard-edged areas catch the eye to suggest instant detail.

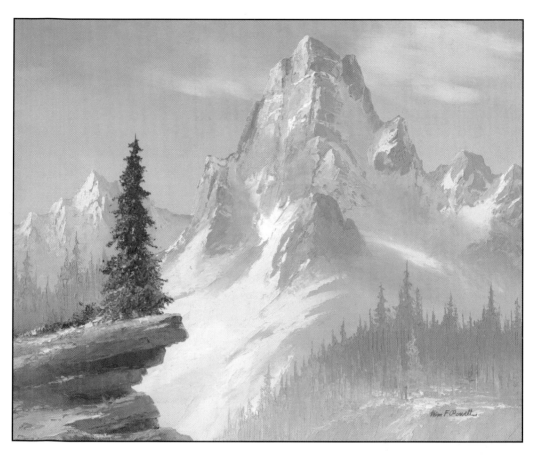

Once the distant hill and trees are completed, mix white with burnt umber and block in the ledge mass. Paint distant trees on this ledge using the same techniques. Make vertical strokes to indicate distant tree forms. Draw in suggestions of top detail. Darken these trees at the bottom and lighten at the top.

Next, make a mix of yellow ochre, burnt umber, and pthalo green for the dark undercolor of the main tree. Use the tip of a small knife to "draw" the branches out from the center. Create texture with tapping strokes. Once the main tree is in, highlight it with small specks of cadmium yellow light and a speck of pthalo green. Spot in trunk suggestion with white, burnt umber, and cadmium orange.

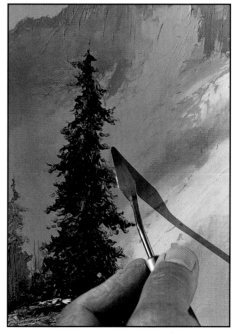

Develop final ledge detail using the light orange sunlight snow mix and the blue shadow mix. Use white with a speck of cadmium orange to paint in the final lights on the mountain.

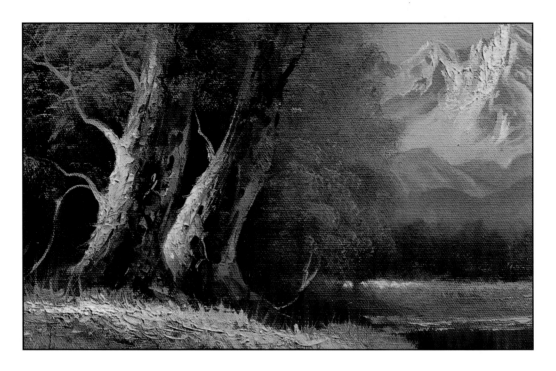

Conclusion

After completing these exercises, I'm sure you must feel that knife painting is a very special technique that can be used to express a variety of moods, subjects, and color manipulations. The painting knife is an extremely versatile tool for creating a wide variety of paint applications—from the most delicate blends to the roughest textures using thick, impasto applications of paint.

Colors can be applied to blend smoothly and evenly or overlaid and interwoven to create a bold statement of hue and value change. Also, in many instances, color appears fresher and crisper when applied with a knife rather than with a brush. The knife lays color down leaving a smooth, unmarred final surface. Paint applied with a brush has minute hair and bristle grooves in the final surface which can break up light rays and alters the appearance of the color.

I hope you have enjoyed this book and the exercises. I also hope that it has inspired you to move on to even greater adventures in knife painting. Don't hesitate to experiment and try any subject. Lastly, never be inhibited by the stiffness of a painting knife, the richness of pure color, or the whiteness of a bare canvas. After all, they are waiting for us to use them to create something beautiful.